CHRYSANTHI MAVROPOULOU-TSIOUMI

HAGIA SOPHIA

THE GREAT CHURCH OF THESSALONIKI

Translated by Nicola Wardle

KAPON EDITIONS

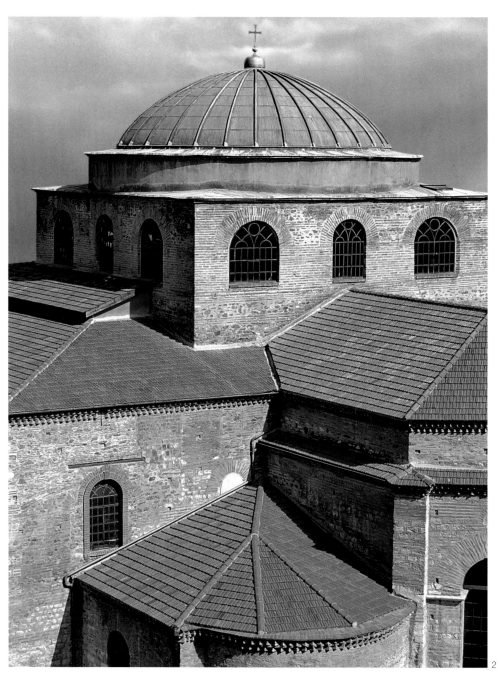

2

ISBN 978-960-6878-71-8

© 2014 KAPON EDITIONS

23-27 Makriyanni Str., Athens 117 42, Greece, Tel./Fax (+30) 210 9214 089
e-mail: info@kaponeditions.gr www.kaponeditions.gr

CONTENTS

1. The west door of the church.

2. Hagia Sophia from southeast.

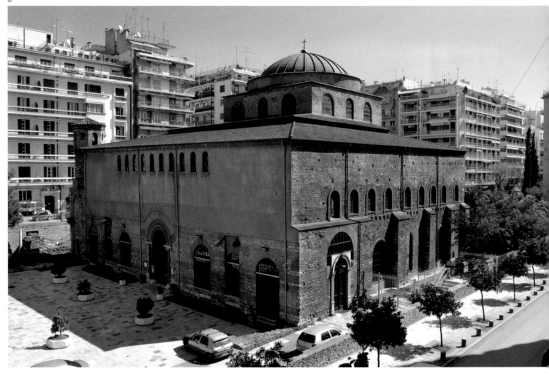

HAGIA SOPHIA IN TIME AND PLACE

3. The church of Hagia Sophia, one of the most important churches of Thessaloniki, is the third in a series of structures on the same site. The structure shows the development from the Early Christian basilica to a cruciform church. Southwest view.

Around 1300 years ago, a great church was built, almost in the middle of the ancient centre of Thessaloniki, in the present day Hagia Sophia square. While the people named it Hagia Sophia, it is not dedicated to the saint of that name, but to the Holy Wisdom of God, in the same way as the church of Hagia Sophia in Constantinople, built during the reign of Justinian (6th century). The present day state of the church does not do it justice, since the ground level of the structure is much deeper than the modern roads, which are elevated as a result of the accumulation of earth in the centuries since it was built. From the level at which the church stands, we can imagine the level of the road and of the buildings contemporary with its construction. The tall buildings which now surround it cut off the light and give a false impression of its original scale. Thus the visitor cannot imagine the size of the church in relation to the buildings of its time, the wealth of the buildings which surrounded it, or the significance it had for the people of Byzantine Thessaloniki.

The church of Hagia Sophia still impresses today with its size and its architectural features, while holding on to its many secrets, a few of which have been revealed by excavation and other research.

The site appears to have been one of the first which was selected for the construction of a Christian church, since the location was important. There was, however, a further reason. As excavations revealed, there were Roman structures located here (a bath house and a Nymphaion which was converted into a Christian baptistry and chapel, today dedicated to Hagios Ioannis (St John), located to the south of the church). The political situation of the period required the consecration of pagan sites and their conversion to the Christian faith with the construction of new Christian buildings.

Excavation has revealed that the first basilica built on this site can be dated to the middle of the 4th century, during the reign of Constantine the Great. It must have been destroyed at the end of the 4th century. Early in the 5th century was built a five-aisled basilica of immense dimensions (115×53 m.). These dimensions have been calculated on the basis of the remains uncovered during the excavations. This basilica, which may have been dedicated to Hagios Markos (St Mark), is believed to have been destroyed by the earthquake which is known to have occurred between 618 and 620. As the results of excavation have shown, the structure was significantly larger than the ground plan of the present day church and extended eastwards from it and westwards as far as Hagia Sophia square. This was confirmed by excavation, which was conducted both before and after World War II, and also during the exploration which occurred after the earthquakes of 1978, when a conservation study of the church was undertaken.

A new church was built on the ruins of this Early Christian basilica in the 7th or 8th century, which, it is estimated, was a third of the size of its predecessor, although still monumental. This church was built with great splendour. This church became renowned. This is evident from the different names by which it is referred to in Byzantine texts (Great Church of Thessaloniki, The great church of God's Holy Wisdom). A great fair was held during the Byzantine era on the occasion of the celebration of its feast day. This fair, which lasted eight days, probably stretched as far as Hermou street, a modern commercial centre.

It is also known that the church had become a spiritual centre, where learned scholars lived or resided for short periods. These men were called Agiosophites (men of Holy Wisdom) or Megalonaites (men of the Great Church) and were known for their spirituality. To the north, beyond the church, and beneath the modern buildings, are the remains of a Bishop's Palace. Its existence is recorded in the oldest historical sources we have concerning the church. Evidently in the 8th century (25 March 797) during the period of Iconoclasm, the exiled iconodule St Theodoros the Studite came to Thessaloniki and visited Hagia Sophia and the bishop, who received him warmly. This information is given in a letter which Theodoros sent to his uncle Platon from Thessaloniki. It is possible to infer from this that the Hierarch of Thessaloniki was not negatively disposed towards the iconodule saint, and may indeed have been an iconodule himself. These conclusions are useful when studying the mosaics of the church.

There is evidence that this was the metropolitan church during the 12th century and maybe even from the 10th century. There is also the opinion that the earlier church of St Mark was already the metropolitan church. When the city was captured by the Franks (1205-1224), the church became the cathedral of the Latin occupiers. After the reoccupation of Thessaloniki by the Byzantines (1224) and until the Ottoman conquest (1430) it operated once again as a metropolitan church. It remained as a Christian

church until 1523/4 when it became a mosque, at which point it was adapted to accommodate the changes essential for an Ottoman place of worship. It is not known why it took almost 100 years for such a central church in the city to be adapted, but the Rotunda was treated in the same way. It is only from a Serbian source that we learn that during the occupation of the city the library of Hagia Sophia was completely destroyed, a library which, if we take into consideration the opulence of the church, would have been extensive. From the sources and from excavations, it is known that burials were made in the narthex and in the south aisle probably throughout the entire Byzantine life of the church. Burials have been discovered which

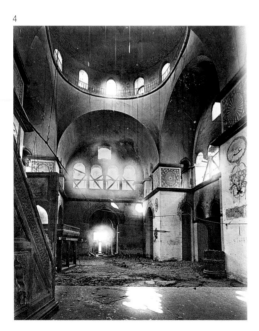

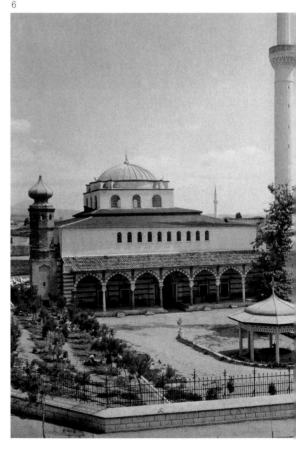

4. View of the interior towards the west side. The Turkish graffiti/inscriptions and the pulpit can be seen (R. Schultz and S. Barnsley, 1888-1890).

5. The church in an old photograph. Interior, east and southeast section.

6. The Hagia Sophia mosque before the liberation of Thessaloniki. Tinted postcard.

date from as early as the end of the 9th century, such as that of Bishop Vasileios, whose bones were placed in the church for veneration. Another tomb built above ground with painted decoration which was found in the south stoa, is exhibited in the Thessaloniki Museum of Byzantine Culture. From the writings of the Patriarch Philotheos Coccinos (second half of the 14th century) comes the information that St Gregorios Palamas was buried here.

During the great fire of 22 August 1890, the church-mosque suffered substantial damage. Restoration of the building was undertaken jointly by the Ottoman and French governments. As a result from the spring of 1908 until 1910 work was undertaken, under the supervision of M. Le Tourneau as engineer, to restore the monument and conserve the mosaics. Work was also conducted later in 1941 and 1961. There is very little information about any of this work. Restoration of damage also occurred after the earthquakes of 1978. In the 1980s conservation of the mosaic of the dome was undertaken *in situ* with traditional materials since they had become detached from the structure to a dangerous degree. Later still began the conservation of the mosaics of the sanctuary.

Since 1913, after the liberation of Thessaloniki from the Turks (1912) the monument has operated as a Christian parish church.

THE HISTORICAL BACKGROUND AT THE TIME OF FOUNDATION AND DECORATION OF THE CHURCH

During the 7th and 8th centuries, the period to which the monument can be dated, there were a number of significant events, which must be mentioned, since the erection of monuments on such a scale is not unconnected with the politics and circumstances of each period.

It has been established that, already from the end of the 6th century but chiefly from the beginning of the 7th century, Byzantium was troubled by the incursions of the Avars and Slavs. At the beginning of the 7th century the Slavs parted from the Avars and settled in southern part of Illyricum in permanent farming settlements where they paid taxes as subjects of the Byzantine Empire. From the middle of the 7th century until the beginning of the 9th century, the Byzantine authorities attempted to tackle the problem and assimilate the Slavs, through military campaigns and administrative measures, by settling Slavs in Asia Minor and with the establishment of Greek populations from the eastern provinces in Macedonia and Thrace. In this way it appears that peace and communications with the hinterland, with Constantinople and other harbours were ensured.

During the 7th and 8th centuries Thessaloniki continued to be, as in the past, an important economic centre for the Balkans, where products from the hinterland and from elsewhere were traded (silk, wool, and linen, objects in gold, silver and precious stones, glass objects, iron and lead).

The Iconoclasm began in 726, and was consolidated in 754 with the Synod at the palace in Iereia on the Asia Minor shore of the Bosphorus, at which the worship of icons was forbidden. Indeed in 731/2 the iconoclast Emperor Leo III the Isaurian (717-741), wanting to curtail the jurisdiction of the Pope at Rome, transferred the responsibility for the

Church of Eastern Illyricum, which belonged ecclesiastically to the Western Church, to the Patriarchate of Constantinople. Thus Thessaloniki belonged not just administratively, but also ecclesiastically to Constantinople.

Monastic life in Thessaloniki, which had already been established from the 6th century, increased. Hermits and monks lived outside the walls of the city and gave it a special character.

The first Iconoclasm ended in 787 with the 7th Ecumenical Synod, which was summoned by the iconodule Irene the Athenian, when she was co-regent with her son Constantine VI who was still a minor. It recommenced, however, in 813 and continued until 843. The Iconoclasm divided ecclesiastical circles and the populace and it is known that many works of ecclesiastical art were destroyed during this period. The position of Thessaloniki and its citizens appears to have been defined by the policies of the ecclesiastical authorities at any moment, sometimes iconoclasts, sometimes iconodules.

The Byzantine emperors during this period encountered, in addition to Iconoclasm, problems with the West, with the Arabs, with the Bulgars and with the Slavs. Even so historical sources indicate that Thessaloniki flourished both economically and culturally. It appears in fact, that important schools were operating there, at which Cyril and Methodios, the Thessaloniki-born brothers, who were missionaries to the Slavs, must have studied during the 9th century. The two brothers were sent to Great Moravia in 863 on a mission to convert the Slavic peoples to Christianity. In 864 the Bulgars adopted

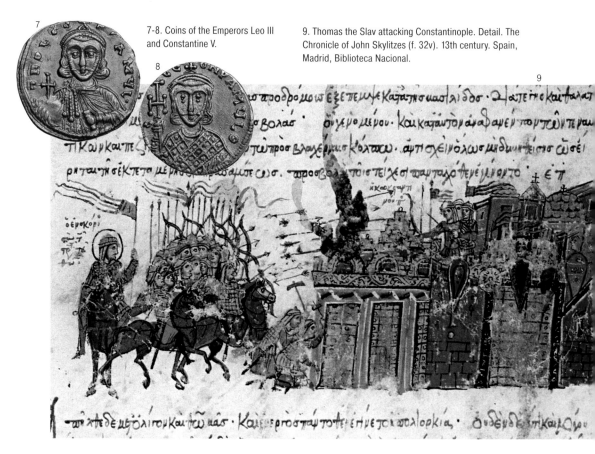

7-8. Coins of the Emperors Leo III and Constantine V.

9. Thomas the Slav attacking Constantinople. Detail. The Chronicle of John Skylitzes (f. 32v). 13th century. Spain, Madrid, Biblioteca Nacional.

the Christian faith and the Serbs followed in 867-874. The conversion to Christianity of the Slavs became a cause for the deep rift between the Pope and the Eastern Church, since the Pope had also attempted to proselytize the Slavs in order to increase his power in Illyria. The conflict was especially divisive in monastic and ecclesiastical circles.

The conversion of the Slavs to Christianity by the Byzantines, which was effected thanks to the political stance of the Emperor Michael III and the Patriarch Photios during the first of his terms as Patriarch (858-867 and 877-886), had great impact, not only during the period, but also for the following centuries, since the Slavs embraced Byzantine culture and the political and cultural map in the region of the Slavic tribes was thus moulded to the advantage of the East.

In the 9th and 10th century the attempt to study the ancient Greek texts, which had already started in the first decades of the 10th century, intensified. The climate which was created during this period in Byzantium, the period when the Macedonian dynasty governed, is usually referred to as the "Macedonian Renaissance" as the result of the revival in literature and art. Thessaloniki, the second most important city in Byzantium after Constantinople, took part in this. It is to this period (7th-9th century) that the foundation of Hagia Sophia is usually attributed, as well as the construction of the mosaics, themes which will be studied below.

THE INSPIRATION FOR THE ARCHITECTURE OF THE CHURCH

Historical evidence for the establishment of the church has not been preserved. Everything that is known, is based on the study of the building itself and its decoration. It is certain that the architect who undertook the planning and construction of the church met with difficulties, which he solved on the basis of experience, inspiration and skill. The first problem was that the church had to be built on top of the remains of the earlier five-aisled basilica and had to preserve respectfully as much as was possible. The second problem was that he did not follow the form of a five-aisled basilica, but chose instead to construct a domed church. Many scholars indeed, believe that the architect wanted to replicate the enterprise which Justinian had completed in the 6th century at Hagia Sophia in Constantinople, and for this reason they date it to the 6th century.

The church is dedicated to the Holy Wisdom of God, as is the archetype Hagia Sophia in Constantinople, but it is not absolutely identical to it. Perhaps it was the limitations of the pre-existing church, but also the different liturgical and social requirements that resulted in the church being built with a dome but also preserving, in part, the tradition of the Early Christian basilica.

The central area, which is almost a square, preserves the form of the Early Christian basilica, since the two columns and two piers on the north and south sides give the impression of a basilica, especially since they divide the space into three aisles, if one takes into account the stoa which surrounds the church on three sides, with the exception of the east. The western section of the stoa forms the

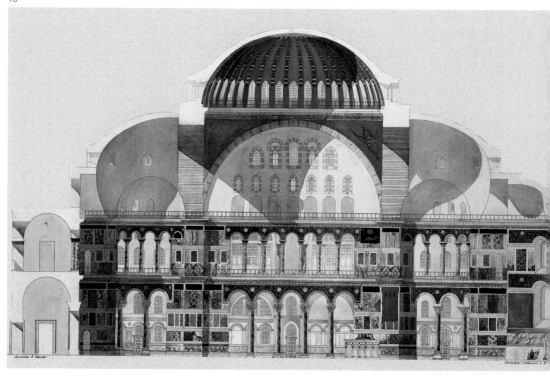

narthex. To the east is the apse of the sanctuary and directly beside it, for liturgical reasons, are two smaller apses, the prothesis on the left and the diaconicon (sacristy) on the right.

In the central space four large piers in the four corners form a square and give it in plan a cruciform shape. The dome is supported on these four pillars through the medium of four semicircular arches. In the four corners which were formed between the arches and the dome there are at each corner four triangles, segments of a sphere which are called pendentives. The dome is placed on top, and its tympanum is four-sided externally. The new church is more enclosed and compact since it expresses a different ideology. The most important feature of the Early Christian basilica was its unrestricted spaciousness, resulting from its long axis, great height, the abundant light from the many windows and the openness of the space. In a basilica,

when the faithful enter the church, their gaze is immediately drawn to the sanctuary apse. In a domed church one's gaze is drawn initially eastwards to the apse, but gradually turns upwards towards the dome, which is considered to be the terrestrial heaven, and is lit with many windows (three in each side). Light for the interior is provided by these windows and by other windows which are located in the exterior walls and in the apse and the impression they give is very different from that of a basilica.

Investigation, conducted both before and after the earthquakes of 1978, showed modifications and repairs from the Byzantine era and during the later Ottoman occupation, which did not, however, alter the square plan. All these alterations are part of the history of the monument and cannot be removed to enable the original form to be reinstated. We know that the building had a gallery on its north and south sides in the

Byzantine period. It appears also that during the 11th century, probably after the earthquake of 1037, the west wall was elevated and a lightwell with ten arched windows was created.

The galleries extended over the narthex as well. In the four corners of the central core of the building they built four small arched chambers. The single pitched roof was unified and reached the base of the windows of the dome and the church acquired an exonarthex. It is known that above the north porch of the narthex there was a small chapel dedicated to Christ the Saviour. Beyond the northwest corner of the church is preserved a tower which led up to the gallery, which was added during the Ottoman occupation. Outside, abutting the north side was the church of Hagios Nikolaos (St Nicholas) and on the south side the church of the Theotokos Hodegetria (lit. The Mother of God showing the Way).

The church not only had a different architectural style from the basilica but also a different system of construction, which may be seen best in the lower part of the exterior walls which belong to the original phase of the church. This consists of alternating courses of dressed stone and brick, a technique which is thought to be Constantinopolitan in origin. The grandeur of this monument is provided by capitals which are in secondary use, such as those of the north apse, which are the only original ones. They were originally used in another church, probably the earlier basilica. The same is the case for the 5th-6th century pulpit, which has been transferred to Constantinople.

10. Constantinople. Hagia Sophia. Cross section. Coloured lithograph. N.E. Efimov, 1835. Moscow, Puskin Museum.

11. Constantinople. Hagia Sophia. Enthroned Virgin and Child in the apse of the sanctuary. 9th century.

12. Constantinople. Hagia Sophia. One of the Archangels who guarded the Virgin Mary in the apse of the sanctuary. 9th century.

11
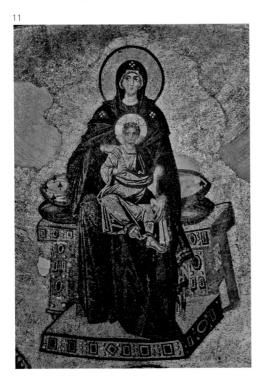

12
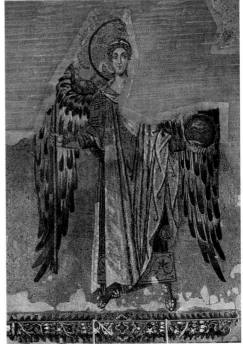

13

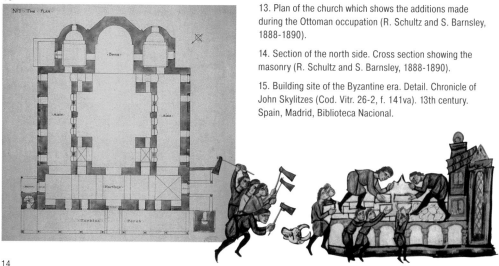

13. Plan of the church which shows the additions made during the Ottoman occupation (R. Schultz and S. Barnsley, 1888-1890).

14. Section of the north side. Cross section showing the masonry (R. Schultz and S. Barnsley, 1888-1890).

15. Building site of the Byzantine era. Detail. Chronicle of John Skylitzes (Cod. Vitr. 26-2, f. 141va). 13th century. Spain, Madrid, Biblioteca Nacional.

15

14

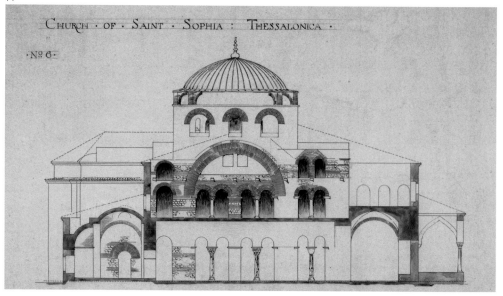

The earliest excavations and the most recent in the last decades have shown that around the church, to the north and south, were administrative and religious buildings as well as buildings for public use (baptistry, episcopacy (Bishop's residence), offices, houses for the priests and other employees, at least five small chapels, baths, cemetery, wells, cisterns, gardens and orchards), which surrounded the church and facilitated its work.

Considerable interest in the building and its decoration began in the second half of the 19th century. Foreign and Greek publications are numerous and the opinions offered are varied. Even today scholarly debate continues and a number of questions remain unanswered.

THE DECORATION OF THE CHURCH AT DIFFERENT PERIODS

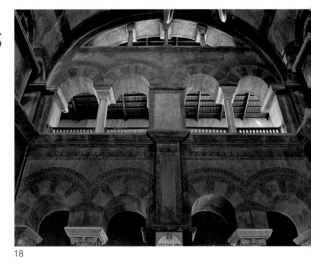

18

Carved capitals and marble facings, which have not been preserved since they were replaced with Ottoman wall-paintings, once decorated the inside of the church. Today the visitor can see a number of mosaics and wall-paintings and the later carved wooden iconostasis, as well as icons. The mosaics are preserved in the sanctuary and in the dome. Of the wall-paintings, only some poorly preserved figures of saints still exist. Previous investigations found small fragments of wall-paintings in the gallery, which indicate that this area was also decorated. Research conducted after the earthquakes of 1978 in the arches, in the pendentives of the dome and in other places in the church did not provide further information, but the investigation cannot be considered complete since the Ottoman wall-paintings, which are part of the history of the monument, were not removed. It is questionable whether there was any decoration at all or if it was perhaps destroyed, which is a more likely scenario.

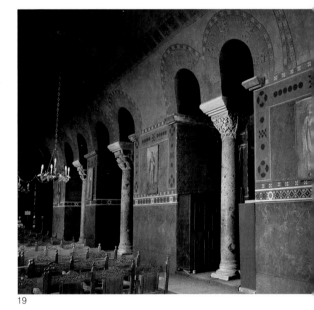

19

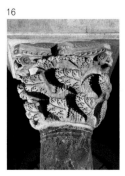

16

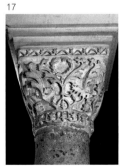

17

16. Column capital with flowering leaves.

17. Tectonic capital.

18. View of the interior, towards the north side.

19. View of the interior, towards the south side.

THE MOSAICS

Mosaics are preserved only in the sanctuary and in the dome. In the semi-dome of the sanctuary is an aniconic decoration with the names of the Emperors Constantine and Irene and of the Bishop Theophilos. In the apse the Virgin is depicted with the Christ Child whilst the entirety of the dome is filled with the representation of the Ascension.

THE EMPERORS CONSTANTINE AND IRENE AND THE BISHOP THEOPHILOS,
THE SPONSORS FOR THE MOSAICS ON THE SANCTUARY VAULT
Inscriptions in capital letters and the monograms of the Emperors Constantine and Irene and Bishop Theophilos can be seen in the mosaics in the semi-dome of the sanctuary, which indicate that they were the donors. The splendour of the decoration indicates a high status donor and the choice of finest quality mosaic artists.

An impressive gold cross, set in a multi-coloured circular Glory with the colours of the rainbow and a background of varied tones of blue, dominates the apex of the vault. The arms of the cross, which do not reach the Glory ring, end in white drops; linked to the Glory by three vertical white lines on the extremity of each arm. This technique makes the gold cross stand out better from the light blue background. From each one of the four inner corners of the cross, groups of three white lines radiate outwards, reaching as far as the boundary. In this manner the Glory with the cross is divided into eight triangles, in each of which are small six-pointed stars which probably symbolize the heavenly firmament. The large rays form the shape of an X, the symbol of Christ and his sacrifice for the salvation of mankind. It appears that even the repetition of the three rays at the corners of the cross is not accidental. In the iconography of the cross many different symbolic meanings are concentrated. The celestial sky, the God-Christ and the three rays (The Holy Trinity?) represent the heavenly kingdom and the Resurrection.

Beneath the cross, to the left and right (in the north and south sections respectively) and above the marble decoration which separates the

beginning of the arch there are rectangular areas. These are divided into small squares of richly detailed decoration with alternating crosses and leaf patterns which are reminiscent of the tree of life. The decoration begins with a band which is formed by alternating patterns of gold-red antithetic heart-shaped motifs and white squares with red dots in the four corners. This band continues round and encloses the whole of the vault of the apse. This motif is significant and will be discussed below. Around the base are two further bands, one gold and one green, both plain, which emphasise the monograms and the misspelled inscriptions on them.

In the southern section the text is preserved legibly: Κ(ύρι)ε, βοήθη Εἰρήνης δεσποίνης and ταπεινοῦ ἐπισκόπου (**Lord help mistress Irene** and [**your**] **humble bishop**).

Similar texts existed on the north side. They are not preserved today but were read in the past. According to publication part of this section read: Κ(ύρι)ε βοήθει Κωνσταντίνου δεσπότου and Κ(ύρι)ε βοήθη Θεοφίλου (**Lord help Constantine despot. Lord help Theophilos**).

The bishop has been identified as the Bishop Theophilos who in 787 signed the

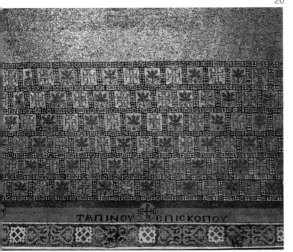

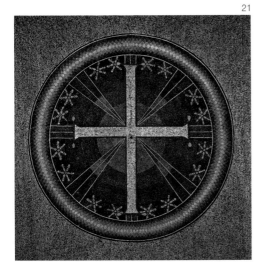

Proceedings of the Seventh Ecumenical Synod of Nicaea at which Irene reinstated the worship of icons, condemning, at the same time, for political reasons, every excess in their worship. The Empress is identified as Irene the Athenian and the Emperor as Constantine VI, her son.

Irene was co-regent with her son until 788, when she was forced to step down, since her attempt to bring back the worship of icons met with strong resistance in the iconoclast circles. The time was not right. Irene took back power and ruled as Empress from 797 to 802, without being able to impose her iconodule politics. The simultaneous mention of two emperors suggests that the mosaics must have been completed between 780 and 788, during which time mother and son ruled as co-regents.

In the last few years it has been noted that the slightly earlier Emperor was Constantine V (741-775), who was married to Irene the Hazara, and it has been proposed securely that this Imperial couple could have been the builders, even if it is not certain that the Bishop Theophilos was contemporary with them. The resulting difference in date is not great, not least since Constantine V died in 775. It appears, however, that the first view is preferred. However, this raises the good question of why Irene and Theophilos chose aniconic decoration. Historical conditions with the intense battles over the question of icons amongst monastic, ecclesiastical and political circles imposed prudent and moderate politics. There is also the view that the mosaics were completed before 787 and the Synod which brought back icons. Immediately after the rule of Irene, the Iconoclasm commenced once again under Leo V of Armenia (813-820). The decoration of the apse must have been done in parallel with that of the arch. This is also shown by the band which we have noted enclosed also the semi-dome of the apse.

20. The mosaic decoration on the south wall of the sanctuary with the preserved inscription naming the Bishop Theophilos and the Empress Irene, after conservation (graphic restoration by Christos Alaveras).

21. The depiction of the cross in a circular Glory in the colours of the rainbow at the top of the eastern arch, symbolises Christ and his sacrifice.

22. Coin of the Empress Irene.

THE VIRGIN AND CHILD IN THE APSE OF THE SANCTUARY

In the apse, the Virgin Mary with the infant Christ seated on her lap sits alone on a gold background. This image does not have any connection with the mosaic decoration of the semi-dome of the sanctuary. This may be explained by the fact that beneath the Virgin Mary a large cross can be made out, traces of which are preserved above the Virgin's halo and beside her shoulder. The cross appears to have covered a large part of the semi-dome of the apse. It is not possible to ascertain if there was anything else besides this cross or if the gold background belonged initially to it, however these questions have been posed. The observation that the decorative band continues into the semi-dome of the apse, shows that at some point the decoration was unified and it is probable that the cross belonged to an aniconic decoration of the vault. This is supported by the gold band which follows on which texts from the Psalms are written in large black letters, in the same style of lettering as those in the arch: **Πληοθησόμεθα ἐν τοῖς ἀγαθοῖς τοῦ οἴκου σου, ἅγιος ὁ ναός σου, θαυμαστός ἐν δικαιοσύνῃ (Let us be filled with the blessings of thy house, Holy is thy Temple, wonderful art thou in judgement)** (Psalms 64(65), 5-6).

A band of blue-green with a twisting golden branch with ivy leaf terminals follows. At the base of the dome, above the band with the twisted branch, is a further text, with the same type of lettering as the former, which mentions the church: **Κ(ύρι)ε ὁ Θεός τῶν π(ατέ)ρων ἡμῶν, στερέωσον τόν οἶκον τοῦτον ἕως τῆς συντελεί[ας τοῦ αἰῶνος ἀσάλευ]τον πρός δόξαν σήν καί τοῦ μονογενοῦ(ς) σου Υ(ἱο)ῦ καί τοῦ Παναγίου σου Πν(εύμα)τος (Lord God of our fathers, make this house firm and unshakeable, for thy glory and the glory of thine only Son and thy Holy Spirit).**

Some letters of this text have been destroyed, since the Virgin's footstool stands over the inscription in this area, which clearly indicates that the mosaic of the enthroned Virgin is later.

The imposing figure of the Virgin is set alone against a shining gold background, seated on a low wooden bench with two cushions, one purple and one blue, her symbolic colours. Above this is a piece of white fringed material with stripes. She wears a deep blue chiton and a mantle in grey and brown tones. She is depicted frontally with her feet turned slightly to the left. She holds the shoulder of the seated Christ Child against her chest with her left hand and, with her right, a small striped piece of cloth (a belt?). Her feet rest on a stool with a long thin cushion. The wooden bench is also decorated with plant motifs, precious stones and pearls.

Her face with its large intense eyes, broad nose and small full lips is framed by a large simple halo, which is marked out from the gold background by a thin line of blue and purple tesserae. Christ, wearing a gold robe and cloak, sits in her arms facing forwards. He reaches out with his right arm in a gesture of blessing and holds a scroll in his left hand.

The figures of the Virgin Mary and Christ are somewhat compressed. This may be attributed to the restrictions imposed by the existence of the decoration around the base of the semi-dome which did not leave sufficient room for a larger figure. However, there is plenty of space above the Virgin's head, kept empty it seems to preserve the earlier cross or because the layout was not completely accurate.

No historical evidence for dating of this mosaic exists. As a result the representation is much discussed. The date given by scholars varies between the second half of the 9th century, the first half of the 11th century and the eighth decade of the 12th century. The view that the lower section is older has of course been published, on account

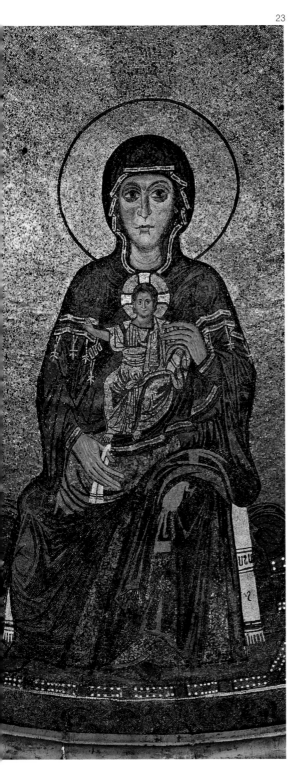

23

of a crack which appears at the level of the Virgin Mary's waist and which divides her figure into two parts. In a recent study, however, it was pointed out that the traces of the arms of the cross exclude the possibility that the cross was destroyed in the upper part. This was confirmed during conservation of the mosaic in recent years, which showed that the representation of the Virgin is a unity and that the impression that it was in two parts was created by the crack.

Those who date the mosaic of the Virgin to the 9th century support this by the similarity of the execution of the mosaic in the dome to the mosaic of the Virgin in the apse in Hagia Sophia in Constantinople (Fig. 11). It is true that the similarity with the Virgin in the apse of Hagia Sophia in Constantinople is remarkable, differing only in that the hands of the Virgin are reversed and in the quality of the execution. A date in the first half of the 11th century is supported by stylistic criteria. The modifications to the mosaics, which have not been completely identified even in the recent conservation work, do not permit positive conclusions. Thus the date of construction for this emotive work will remain problematic, probably for ever.

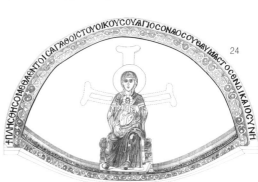

24

23. Mosaic of the Virgin and Child in the apse. Level with the shoulders and above the halo of the Virgin can be made out traces of an earlier iconoclastic cross. The mosaic was dated to the 9th, 11th and 12th centuries.

24. Drawing of the semi-dome of the conch with the image of the cross and of the Virgin.

THE GREAT MOSAIC OF THE ASCENSION IN THE DOME, A WORK OF GREAT INSPIRATION

Who it was and why he decided to depict the Ascension on the dome is a mystery. Since nothing was preserved on the pendentives and on the arches which supported the dome, we cannot imagine the composition of the whole. The choice of the Ascension as the theme, which also implies the Resurrection and the heavenly kingdom, but principally the organisation of the composition indicates the high status of the sponsor and the quality of the artist. The enormous vivid composition fills the entire dome and is split into two zones with the ascended Christ in glory at the top of the dome (the heavenly zone) and in the lower zone the Apostles and the Virgin Mary with the angels, the rocky terrain and the olive trees which symbolise the Mount of Olives, where, according to the text, the event occurred (the earthly zone). The scene is framed by a decorative band at the base of the dome, an exceptional piece of artwork, which is filled with flowers and fruit (motifs relating to paradise).

At the apex of the dome, set in a shining gold background Christ is depicted in a circular Glory, which is made up of four superimposed circles, which are dominated by the blue shades of the sky. Christ is seated on a semicircle of sky and the background behind him is a grey-white. He wears a gold chiton and mantle and a gold halo with a cross. In his left hand he holds, as is usual, a closed scroll, which is supported on his left thigh, and he raises his right hand in a gesture of

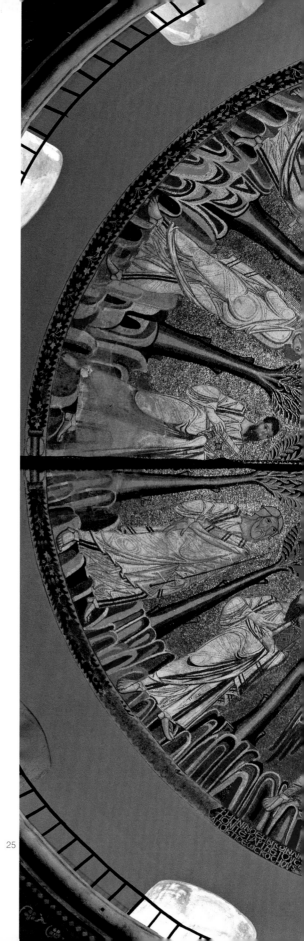

25. The representation of the Ascension in the dome, a work completed after the Iconoclasm, is a large circular depiction of impressive size and composition. It is one of the finest examples of Byzantine art.

25

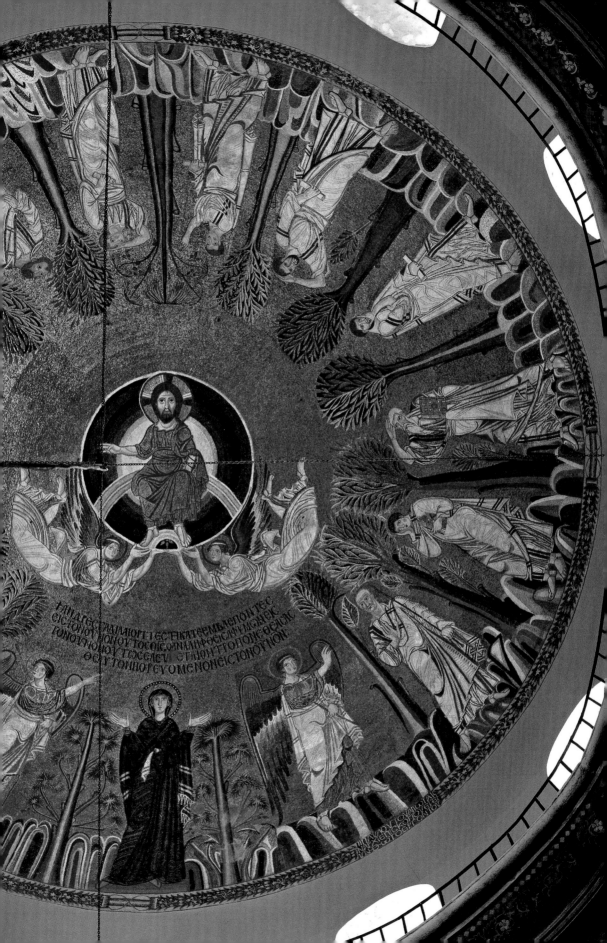

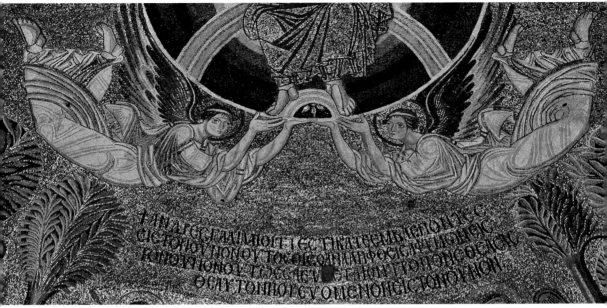

blessing. His tranquil figure occupies a small area and is somewhat compressed and weighed down despite the great space of the dome. It appears that the artist chose to reserve a greater space for the winged angels who face each other and hold the Glory. Their execution is masterly, their bodies filled with movement and joy, they almost fly horizontally above the gold background. Their white chitons and mantles, their wings raised in vigorous movement, their broad, calm faces and rich locks of hair create an airy transcendental whole which shines out and reinforces the concept of Divine light and Divine energy. The superb rendering of the two angels (one of the most beautiful representations in Byzantine art) makes us believe that the foreshortened figure of Christ was deliberate and not a result of artistic weakness.

It is followed by an equally impressive composition with the twelve Apostles and the Virgin Mary with an angel to her left and right, who stand on a rocky terrain, which runs around the base of the dome above the garland. All of the figures are set in a shining gold background and are separated from each other by trees. The whole composition separates into two parts, the east and the west. Interestingly, from the rendering of the foliage, an olive tree stands beside every Apostle with the exception of the Virgin Mary who is depicted between palm trees. The two Apostles immediately opposite the Virgin Mary in the west part are also between palm trees. The palm trees differentiate the Virgin Mary, but we do not know why the two Apostles are marked out in the same way. In the Virgin Mary's case we can suggest that this differentiation was intentional, since the Virgin Mary was not present at the Ascension. It is, however, possibly a clever aesthetic concept to emphasise the east-west axis.

26. The angels who hold the Glory of Christ are some of the most beautiful figures in Byzantine art.

27. The face of the ascended Christ. Detail. The large calm eyes with their gaze fixed above the horizon are a characteristic trait.

28. The face of the Virgin Mary. Detail.

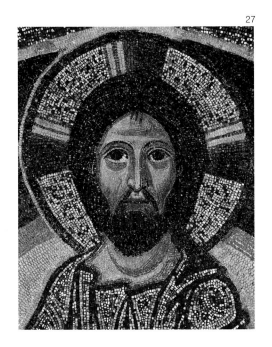

It is also a brilliant aesthetic concept that the trees and the figures play an equal role in the composition. The tops of the trees and the heads of the Apostles unite to form a circle around the Glory of Christ in an impressive composition. The Apostles have neither halos nor inscriptions with their name. They wear chitons and mantles and many of the figures give the impression they are ancient philosophers. Each one has, however, individual features which permit the identification of almost all of them.

THE VIRGIN WITH THE ANGELS

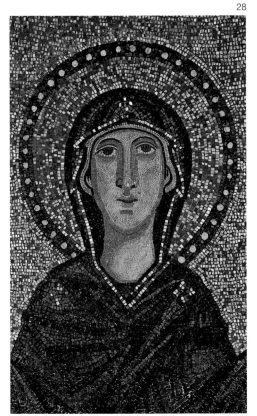

28

The depiction of the Virgin Mary, even if she was not present at the Ascension, is included for the sake of economy in composition and symbolises her role as the intermediary between God and man and between heaven and earth. She stands proud and upright with her hands raised to the level of her shoulders, palms forward in a prayerful stance, with an unworldly expression on her face and her eyes raised upwards. She wears a deep blue chiton and mantle and her under-shift is red like the Emperor's. From her belt hangs a striped cloth.

The two angels with large unfurled wings are beside her, but are turned towards the Apostles, as the moment requires. They both hold in their hand a *caduceus* (a symbol of the messenger, just like Hermes in antiquity), which has a finial of precious green stones. The other hand is raised towards the risen Christ and towards the Glory. Above their heads is written the text of the words with which they addressed the Apostles according to the Acts of the Apostles (1, 11). Ἄνδρες Γαλιλαῖοι, τί ἑστήκατε ἐμβλέποντες εἰς τόν οὐ(ρα)νόν; Οὗτος ὁ Ἰ(ησοῦ)ς ὁ ἀναληφθείς ἀφ' ὑμῶν εἰς τόν οὐ(ρα)νόν οὗτος ἐλεύσεται ὅν τρόπον ἐθεάσασθε αὐτόν πορευόμενον εἰς τόν οὐ(ρα)νόν.

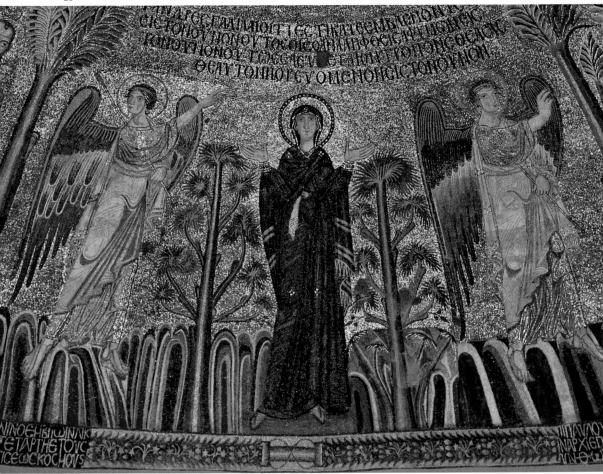

29. The Virgin Mary with angels to the left and right. The Virgin is depicted in the Ascension, although she was not present at the event, because in this way her role as the intermediary between heaven and earth and between God and man is symbolised.

(Men of Galilee, why do you stand looking up towards heaven? This Jesus, who has been taken up from you into heaven, will come in the same way as you saw him go into heaven).

These figures with their classically beautiful profiles, with the colours of their clothing and wings, with their majestic and easy movement, are amongst the most exquisite works of Byzantine art. While some small later modifications, largely on their faces are visible, these must belong to work which was undertaken in 1908-1910 or later, these did not, however, alter the final impression. The figures of the angels which hold the Glory and the angels beside the Virgin Mary with their joy and their movement, as opposed to the solemn forms of the Virgin and Christ, create a striking contrast. They give the composition a note of optimism and show another world beyond the earthly, where the faithful go after their death, just as heralded by the Ascension.

We can easily see the prototype for

the artist for these forms, if we take into consideration the so-called imperial art, to be seen in the illumination of manuscripts and also in the artistry of the mosaics in 9th century Constantinople and of the lost mosaics of Nicaea, which were burned during the Asia Minor catastrophe. Their stylistic characteristics are very similar to those of the so-called Macedonian Renaissance, which retained many features from ancient Greek art, which saw a revival at that time.

FACIAL AND STYLISTIC REPRESENTATIONS OF THE APOSTLES. THE IDENTIFICATION OF THE FIGURES

The depiction of the Apostles who follow the angels is completely distinctive. It appears that the artist who sketched the composition studied the space and wanted to depict the subject in a manner which developed after the Iconoclasm but in an entirely personal style. The theme was already well known, but was sometimes static, and at other times had a bias towards the Apostles. The existence of a large, open space provided the mosaicist with the possibility of conveying the location (Mount of Olives) and the figures in an equal and equivalent execution. In this way he created a calm, balanced, transcendent impression, the like of which had not been seen in any earlier, contemporary or later versions of the same theme. The trees contribute to this impression, especially the olive trees with the movement of the leaves in two directions and the differentiation in the colours of the leaves. Even though they are representations, half of the leaves are silver and half golden as if depending on the movement of the wind, as happens in reality. The artists who rendered the depictions were outstanding. Perhaps this indicates that we are not far from the Iconoclasm, during which time the artists focussed more on the representation of

nature and landscapes, since they were forbidden to portray figures of saints.

The same level of knowledge and ability can also be found in the representation of the rocky terrain at the base of the composition. This terrain (the Mount of Olives) is represented schematically by rocks in two zones with a variety of colours. It is striking that this composition works as an independent scene, reminiscent of the concepts of modern art, as expressed in the 20th century.

The individual role and depiction of each Apostle, each with his own characteristics, is also a sign of artistic independence. The careful representation of the distinctive features of each shows that their depiction is in complete harmony with the theoretical positions and arguments of the iconodules about the representation of saints: the attainment of a "likeness" is the fundamental excuse for the depiction of religious figures, moreover the likeness gives the icon the sanctity of the subject depicted. As such they present a unified whole, especially as they participate in the event through their movement and expression, despite the individuality of each figure. Some figures are rather static, others more mobile and others again transcend the standards of Byzantine art. Their depiction also presents different conventions, since some forms are almost classical in style and, as noted already, are reminiscent of the portrayal of philosophers in ancient Greek art, while others have elements of the so-called "anti-Classical" style of art. This variation in execution may signify different artists, though this is not certain. However, different styles in the same works coexist frequently in almost all the art work in great monuments, as, for example, in the mosaics of the Chora monastery in Constantinople.

The Apostles are portrayed in an almost hieratic arrangement, separated, as we saw, into two sections (hemispheres). In the south choir, the first in line is the Apostle Peter and in the

north choir, the Apostle Paul, representatives of the two Churches, West and East respectively.

Peter is represented, as is usual, as an old man with stylized short white hair, big bright eyes. He raises his right hand to his chest, broad palm outwards in a gesture of wonder and amazement at the event. He holds the key to the Kingdom of Heaven in his left hand and a long cross-bearing staff. This staff does not symbolise martyrdom, since the martyr's staff is not as long. According to the texts Peter was distinguished, for ecclesiastical and political reasons by the Church of Rome as the primary apostle with the staff and the *Traditio Legis*, to emphasise that this Church had the primacy. The cross which Peter has in his hand is similar to that which Christ usually holds in Early Christian art after the middle of the 4th century and is a symbol of victory after the triumph of Christianity. The prototype can be seen in Imperial art from the time of Constantine the Great, in which the emperor was represented with the "symbol of victory". In this way parallels were created between the heavenly and the earthly kingdoms and between the heavenly and the earthly state. Christ holds the trophy-cross with which he conquered death as a "symbol of kingship" and as a "victory trophy". This symbol of the "risen Christ" is held by Peter, who is considered by the Western Church as successor for Christ's work on earth.

Paul is depicted on the other side. He was not present at the Ascension, but is always represented at the scene. He takes part, in the same way as the Virgin Mary, for the sake of economy, to emphasise the concept of a single and indivisible Church which continues the work of Christ and to stress the role he played in the spread and consolidation of Christianity. His portrayal follows the tradition which represents him frontally with a pronounced bald head and a long dark beard. In his left hand he holds a closed Codex (a red-brown book) which demonstrates the great importance of his work and he raises his right hand to his chest. His figure is sombre with gaze raised above and beyond this world as if he was not taking part in the event.

The four Evangelists were usually depicted beside the Apostles because of their work and their role in the spread of Christianity. Beside Peter in the northern part stand John and Matthew, however, there is an important difference in this scene.

The Evangelists do not immediately follow the Apostle Paul, but instead there is the Apostle Andrew the Protocletus (First-called), a difference which is significant and departs from the historical traditions of that period. In opposition to the promotion of Peter, the Byzantine Church put forward Peter's brother, the Protocletus Andrew, who is depicted in this scene with the cross, with the same "symbol", therefore, as Peter. This promotion [of Andrew] began in 356, when they moved the remains of the Apostle Andrew from the charge of the Emperor Constantine II, and placed them in the Church of the Holy Apostles in Constantinople. A little later the tradition was created that the Apostle Andrew founded the Byzantine Church in Constantinople. The ensuing iconographical similarities of the two brothers must have been established in the capital.

In the second half of the 9th century, the tension between the Eastern and Western Churches, which already existed, deteriorated as a result of the conversion of the Slavs. The issue was not only religious, but also had political dimensions, since the Pope sought to revive the former importance of the Church in

30. Apostle Paul holding the cross-bearing staff, the symbol of the ressurected Christ. John the Evangelist depicted as a youth and not an old man, as is more usual, recalls depictions of him in representations of the Crucifixion.

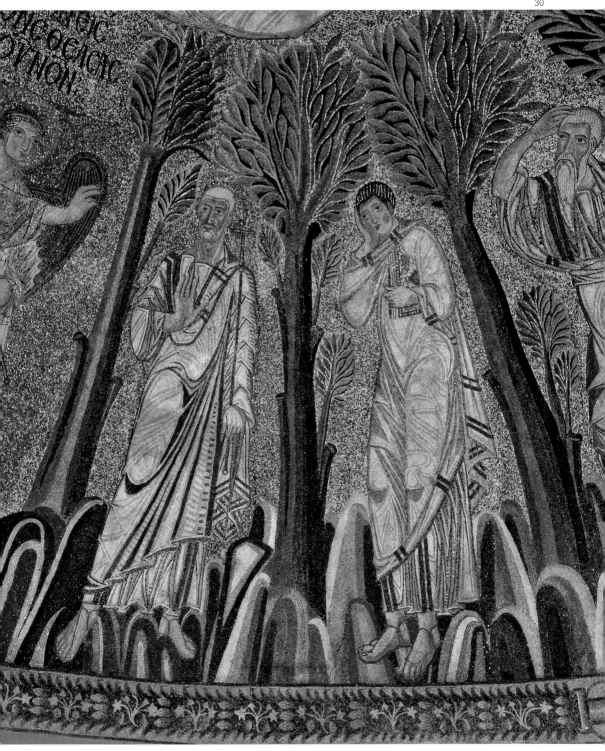

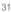

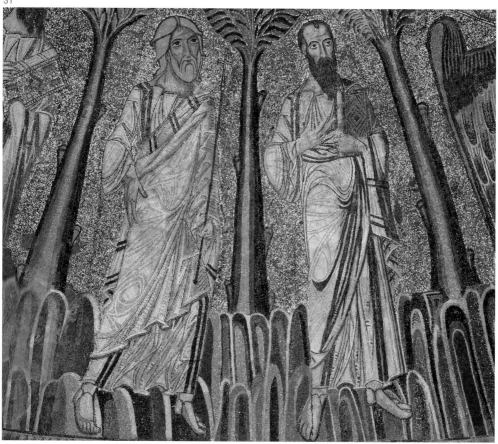

Rome and to expand its influence in Illyricum, which in 731/2 had been attached definitively to the Church of Byzantium. Finally the Emperor Michael III and the Patriarch of Constantinople, Photios managed to emerge victorious from this tussle and took on the conversion of the Slavs. This event was not only of decisive importance for that period but also to the present day, since the religious, political and cultural maps changed to the benefit of Byzantium, a factor which brought to a head the differences between the Churches.

The Pope stressed the primacy of the Church in Rome, since it was founded by the Apostle Peter, and cast doubts on the legitimacy of the Patriarchy of Constantinople since, in his opinion,

it was not founded by any Apostle. The Byzantines in turn stressed that their Church was founded by the Protocletus Apostle Andrew. These tense debates influenced the iconography. In the light of this, the representation of Andrew immediately after Paul has special significance, since he was considered the founder of the Eastern Church and shows a clear intent to stress the presence of Andrew.

Following Andrew are the Evangelists Mark and Luke. All of the Evangelists share the detail of a closed, richly decorated, Gospel that they hold in their left hands. They are differentiated, however, in the position of the right hand, their facial features and expression.

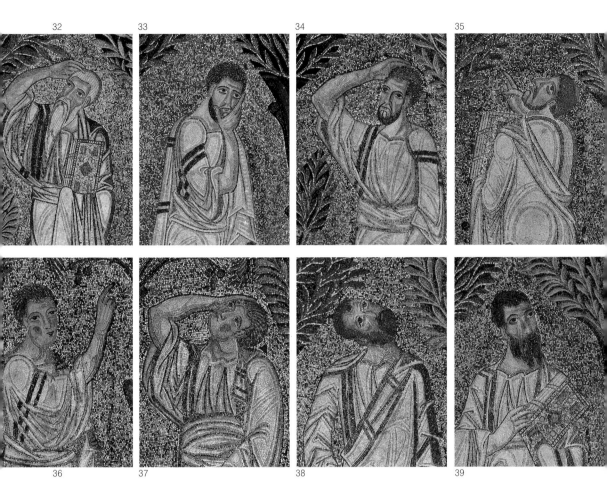

32 33 34 35

36 37 38 39

The portrayal, for example, of the Evangelist **John**, who follows immediately after the Apostle Peter in the southern choir, is not the familiar elderly figure of the evangelist but a youthful one. He raises his right hand and touches the right cheek. His form and stance are reminiscent of the representation of the favourite disciple of Christ at the Crucifixion, which is unusual.

The Evangelist **Matthew** is depicted in the usual way as an old man. Not only are his large eyes troubled, but the position of his right hand on his head, as if he was trying to protect it, show that he is stunned by the event.

The Evangelist **Mark** who follows Andrew,

31. Apostle Andrew holds a cross-bearing staff, just as the Apostle Paul holds a Codex, indicating his writings.

32. Evangelist Matthew in venerable old age.

33. Apostle James showing deep concern.

34. Apostle Simon surprised by the event.

35. Evangelist Luke, with diaphanous robes which are strongly reminiscent of ancient Greek statuary.

36. Apostle Philip as a youth holding a scroll in his left hand and pointing to the ascending Christ with his right hand.

37. Apostle Thomas attempting to come to terms with the event.

38. The Apostle pictured is possibly Bartholomew. The way his head is turned back in his attempt to see the ascending Christ is unusual.

39. Evangelist Mark lost in his own thoughts.

is more composed and has a calm thoughtful expression. He is a mature figure with short, dark brown hair and beard holding the Gospel in both hands.

Beside Mark stands the Evangelist **Luke**. His portrayal is unique and deserves discussion. Luke has his back to the viewer and points with his right hand to the ascended Christ. In his left hand he holds a closed Gospel, which covers most of his body. His face, in profile, is particularly distinct, with a pronounced chin and large eyes. His figure has parallels with his portrayal in the 9th century wall-paintings of the Ascension in the Rotunda. The way that the lower part of the body is depicted is particularly impressive, where the diaphanous nature of the material allows the buttocks and legs to be clearly seen beneath, the size and curves of which give a strong and unconventional impression of a holy figure. The depiction is reminiscent of ancient Greek and Hellenistic statuary.

It is not possible to identify all the Apostles who follow the Evangelist **John** in the southern choir and close the circle of the lower zone as far as the Evangelist **Luke**, with absolute certainty, since there are no labels with names and since the sources sometimes disagree about the names of the Apostles who were present at the Ascension. As a result of this the iconography does not always follow the same rules for their portrayal. Their identification by name is based on other familiar compositions where they are labelled.

In the north section, beside the Evangelist Matthew, stands, without a doubt, the Apostle **James**. His facial characteristics are recognisable from other depictions of him, but also from the wall-painting of the Ascension in the apse of the Rotunda in Thessaloniki. He has short brown hair and a beard. The gesture of his right hand is characteristic, since he clasps the left side of his face (his cheek) with his palm in an expression of deep contemplation. Next to him is probably **Simon**, a man of mature age with short hair and beard, who raises his right hand to his head. Immediately after the palm tree beside him is probably the youthful figure of **Philip**, who raises his right hand and gestures towards the risen Christ. On the other (south) side next to the palm tree is **Thomas**, also a young beardless figure, who looks at the ascended Christ, also in deep thought, clasping the right side of his head with his right palm. Finally there is a further mature figure next to the Evangelist Mark, who completes the group of Apostles with a completely unusual head position. He turns his head unnaturally in trying to see the event. It is likely to be **Bartholomew**.

Out of the representations of this theme so far known up to the 10th century the Ascension of Hagia Sophia is the most composed and most freely developed and indeed the available space contributes to this. It is considered to be one of the most representative examples of the pure Byzantine style, which was created after the end of the Iconoclasm (843) with the triumph of Orthodoxy both in minor works of art but also in large monumental pictures, especially in Cappadocia.

The composition is interesting not only because of the way it is ordered, but also because of the exceptional quality with which the figures were executed. A characteristic of the figures is the rendering of the fall of the clothing and hair, which is conveyed with deep contours, and the hands with their large palms. The faces have long broad noses, small foreheads and mouths, and large expressive eyes with metallic lucidity in their depths. The

40. Interior view of the church showing the mosaic in the dome.

tradition of ancient Greek art is also marked. The characteristics of this tradition can best be seen in the manuscript art of the so-called Macedonian Renaissance of the 9th and 10th century and in Hagia Sophia in Constantinople, a factor which directs us to that period, especially in the second half of the 9th century for the execution of this scene.

However, at the base of the dome, as we have seen, two inscriptions are preserved, which must be discussed.

THE INSCRIPTIONS, ARCHBISHOP PAUL AND HIS RELATIONSHIP TO THE MOSAICS

The inscriptions are in capitals in three rows, and found in the garland at the base of the dome cutting it in two places in the eastern section, below the feet of the angels who are beside the Virgin Mary.
The north side reads:
Μηνί Νοεμβρίῳ ἰνδικτιόνι τετάρτη ἔτους από κτίσεως κόσμου Ϛ´ (In the month of November in the 4th Indiction, 6...Anno Mundi).
The south side reads:
Ἐπί Παύλου τοῦ ἁγιωτάτο(υ) (ἡμῖ)ν ἀρχιεπισκόπου ἐγέ(νετο) (σ)ύν Θ(ε)ῷ τό ἔργον τοῦ(το) (In the time of Paul our most holy archbishop was this work done).

The north inscription provides the date of the inscription from which however, only the Ϛ is preserved which gives the year 6000 Anno Mundi (from the year of creation). The destruction at this point in the inscription with the dates has fostered much academic debate and concern. Indeed the view has been proposed that the inscriptions belong to an earlier phase and that they were preserved and enclosed within the decorative garland. Another view holds that the garland and the inscription are older than the mosaic of the Ascension. Thus on the basis of

the Early Byzantine chronology which gives the years 495, 510, 540, 570 and 690 for the 4th Indiction, 690 is preferred for the date of the inscription, which could date the construction to the same period. The decorative band has an essential connection with the mosaic of the Ascension, which it frames in an elegant circle.

The dates which have emerged find some support in the restoration of some letters in the northern inscription. Indeed the view has recently been proposed, on the basis of a new restoration, that the inscriptions were done in 840 (6349 Anno Mundi, which corresponds to the 4th Indiction) when the archbishop was Leon the Mathematician, an important person of the time, and that it had some iconoclast decoration which was replaced perhaps because it was destroyed in the earthquakes of 896. In accordance with this view the mosaic of the Ascension could have been executed in the first half of the 10th century, in the period of the Macedonian Renaissance.

In the middle of the 1980s during the conservation of the mosaics after the 1978

41

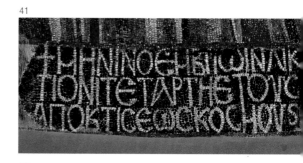

42

earthquakes, we established that, as in other parts of the mosaic, there had been modifications to the inscriptions as well (such as replacement of tesserae and careless restoration), alterations which show that the craftsmen who carried them out did not understand the subject. They probably result from restoration in 1908-1910 or perhaps even later.

It is certain that the estimation of the date of the inscription can be no more than hypothetical and so to determine the period during which the mosaic was created we must rely on other evidence.

Starting from the fact that the iconographic and stylistic elements indicate the so-called Macedonian Renaissance of the 9th to 10th centuries, we can suggest that this important work should be related to the more general political stance of the Church and the Patriarch Photios who had the aim of strengthening the power of the Church and the Byzantine Empire in the period of conversion of the Slavs as well as addressing a variety of other problems. The work clearly will have impressed both locals and foreigners in that period and still impresses even today.

It has already been proposed that the mosaic should be dated to the year 885 which corresponds to the 4th Indiction. Paul is mentioned as archbishop of Thessaloniki in that year. He was a friend of the Patriarch Photios, one of the great figures of Byzantium, who reorganised the Church after the struggles of Iconoclasm. It is an attractive idea to assign the work to that period, while waiting for chance and research to provide more evidence.

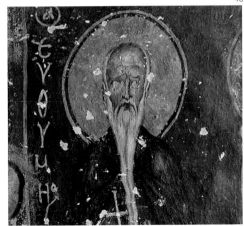

WALL-PAINTINGS FROM THE 11TH CENTURY

From the small fragments of wall-painting which were found during excavation of the galleries and the few wall-paintings that remained *in situ*, unfortunately in a poor state in the arches of the narthex, it appears that the church was also decorated with wall-paintings. We are not in a position to know if all the wall-paintings belonged to the same period as the fragments that were saved were very small. Those preserved in the narthex depicted holy monks on a deep blue background. All held small crosses. The depiction of the local St Theodora is important. The wall-paintings date to the first half of the 11th century and more specifically to the second quarter of it as there are stylistic similarities with the wall-paintings of Hagia Sophia in Ochrid, Nea Moni in Chios and the Church of the Panagia Chalkeon in Thessaloniki. It is considered most likely that they were executed as a result of the opportunity that arose for renovation after the earthquake of 1037.

41. The inscription on the representation of the Ascension with the date given for the construction work: the last letters are missing.

42. The inscription with the name of Archbishop Paul.

43. St Euthymios, wall-painting in the narthex. 11th century.

SELECT BIBLIOGRAPHY

Cormack R., The Apse Mosaics of St. Sophia at Thessaloniki, *ΔΧΑΕ* Ι΄ (1981), p. 111-135.

Diehl Ch. - Le Tourneau M., Les mosaiques de Sainte Sophie de Salonique, *Mon Piot* XVI (1909), p. 39-60.

Diehl Ch. - Le Tourneau M. - Saladin H., *Les monuments chrétiens de Salonique*, Paris 1918.

Grabar A., *L'iconoclasme byzantine*, Paris 1957.

Kalligas M., *Die Hagia Sophia von Thessaloniki*, Würzburg 1935.

Mavropoulou-Tsioumi Ch., Hagia Sophia, in: *Mosaics of Thessaloniki, 4th-14th Century*, ed. Ch. Bakirtzis, Kapon Editions, Athens 2012, p. 241-295.

Pelekanidis S., I mosaici di Santa Sophia di Salonica, *Corsi Rav* 11 (1964), p. 337-349.

Pelekanidis S., Bemerkungen zu den Altarmosaiken der Hagia Sophia zu Thessaloniki und die Frage der Datierung der Platytera, *Βυζαντινά* 5 (1973), p. 97-107.

Spieser J., Inventaires en vue d'un recueil des inscriptions historiques de Byzance: Les inscriptions de Thessalonique, *Travaux et Mémoires* 5 (1973), p. 145-180.

Βελένης Γ., Η χρονολόγηση του ναού της Αγίας Σοφίας Θεσσαλονίκης μέσα από τα επιγραφικά δεδομένα, *Θεσσαλονικέων Πόλις* 13 (2004), p. 72-81.

Γκιολές Ν., *Η Ανάληψις του Χριστού βάσει των μνημείων της Α΄ χιλιετηρίδος*, Athens 1981.

Θεοχαρίδου Κ., Τα ψηφιδωτά του τρούλου στην Αγία Σοφία Θεσσαλονίκης. Φάσεις και προβλήματα χρονολόγησης, *ΑΔ* 31 (1976) Μελέται, p. 265-273.

Θεοχαρίδου Κ., *Η αρχιτεκτονική του ναού της Αγίας Σοφίας στη Θεσσαλονίκη*, Athens 1994.

Μαρκή Ε., Η Αγία Σοφία και τα προσκτίσματά της μέσα από τα αρχαιολογικά δεδομένα, *Θεσσαλονικέων Πόλις. Γραφές και πηγές 6000 χρόνων*, Thessaloniki 1997, I, p. 62-71.

Μαυροπούλου-Τσιούμη Χρ., Η ζωγραφική στη Θεσσαλονίκη τον 9ο αιώνα, *Πρακτικά του Συνεδρίου προς τιμήν και μνήμην των αγίων αυταδέλφων Κυρίλλου και Μεθοδίου της Θεσσαλονίκης, Θεσσαλονίκη 10-15 Μαΐου 1985*, Thessaloniki 1986, p. 393-410.

Μαυροπούλου-Τσιούμη Χρ., *Βυζαντινή Θεσσαλονίκη*, Thessaloniki 1992.

Μέντζος Α., Συμβολή στην έρευνα του αρχαιότερου ναού της Αγίας Σοφίας Θεσσαλονίκης, *Μακεδονικά* 21 (1981), p. 201-220.

Μπακιρτζής Χ., Νεότερες παρατηρήσεις στην κτητορική επιγραφή του τρούλου της Αγίας Σοφίας Θεσσαλονίκης, *Βυζαντινά* 11 (1982), p. 165-180.

Παναγιωτίδη Μ., Η παράσταση της Ανάληψης στον τρούλο της Αγίας Σοφία Θεσσαλονίκης. Εικονογραφικά προβλήματα, *Επιστημονική Επετηρίς Πολυτεχνικής Σχολής Πανεπιστημίου Θεσσαλονίκης ΣΤ΄* 2 (1973-1974), p. 69-82.

Πελεκανίδης Στ., Νέαι έρευναι εις την Αγίαν Σοφίαν Θεσσαλονίκης, *Πεπραγμένα του Θ΄ Διεθνούς Βυζαντινολογικού Συνεδρίου, Θεσσαλονίκη 12-19 Απριλίου 1953*, Athens 1955, p. 398-407.

SOURCES OF ILLUSTRATIONS

ARCHIVES: KAPON EDITIONS ARCHIVES: figs 6, 11-12 • phot. M. Kapon figs 1-3, 18-19, 40, 43 • phot. G. Fafalis figs 20-21, 23 • CHRYSANTHI MAVROPOULOU-TSIOUMI ARCHIVE: phot. S. Chaidemenos figs 26-39, 41-42 • EFTYCHIA KOURKOUTIDOU-NIKOLAIDOU ARCHIVE: phot. M. Skiadaresis fig. 25 • BRITISH SCHOOL AT ATHENS ARCHIVE - Byzantine Research Fund Archive Collection: figs 4 (BRF 02-01-07-097), 13 (BRF 01.01.07.076), 14 (BRF 01.01.07.080) • DUMBARTON OAKS: figs 7-8, 22 • BIBLIOTECA NACIONAL DE ESPAÑA: figs 9, 15.
BOOKS: E. Kourkoutidou-Nikolaidou - A. Tourta, *Wandering in Byzantine Thessaloniki*, Kapon Editions, Athens 1997: figs 5, 16-17 • V. Davidov, *Travelling Notes*, Commercial Bank of Greece, Athens 2004: fig. 10.

ARTISTIC DESIGNER: RACHEL MISDRACHI-KAPON
ARTISTIC ADVISOR: MOSES KAPON
COPY EDITOR: DIANA ZAFEIROPOULOU
DTP: ELENI VALMA, MINA MANTA
PROCESSING OF ILLUSTRATIONS: MICHALIS TZANNETAKIS
SECRETARIAT: MARIA KATAGA
PRINTING: KORDISTOS Graphic Arts
BINDING: J. BOUNDAS – P. VASILIADIS Co